The Children's Promise

The Children's Promise

A VISIT TO A SPIRITUAL GARDEN

≈

Written & Illustrated by
ARLENE GRASTON

Visibles, Inc. New York, NY

With very special thanks and much love to
Drew, Janet, Julianne, and my Charlie

ISBN 978-0-9848814-3-7

Book design by Arlene Graston and Drew Stevens

Title page illustration: We Meet

Other books by Arlene Graston

SPECIAL FRIENDS
Tales of Saints and Animals

THUMBELINA

IN EVERY MOON THERE IS A FACE

DO YOU REMEMBER?
Whispers from a Spiritual World

FOR YOU

who hears
beyond the words

who knows
beyond the telling

CONTENTS

ENCHANTMENT

PREFACE

∼

MODERN CIVILIZATIONS portray life as a
meaningless science project, and so we have the
world we have. Meaning is life coming from *within*
us. Without meaning I cannot feel alive. I am not
an empty Being who needs to be filled up; I am life,
giving forth from the eternal vastness within. Each
of us does, in uniquely magnificent ways.

I came into this human life knowing I was entering
a dream—a dream that turned out to be about
limitation. But to my inner self, existence is a poem
expressing unlimited substance and significance.
I become uneasy when I attempt to imitate the
outside world. Thankfully, my writing (my art)
comes to remind me who I really am.

The language of my inner self is not of the intellect,
and it isn't clever or smart in the way of the
sophisticated society I live in. My quiet self says
simple truths simply. I am grateful for its funny

little stories that show me another way to think
. . . to feel. It seems to speak to a child. Haven't
we been told that "Only a little child can enter?"
Spending time in its kind and gentle world leaves
me feeling I have done no wrong.

Even in this overwrought world, a soundless
voice full of love is speaking. It is our truest self.
I believe this inner self is what the world is looking
for. We only need to stop "knowing so much" to
know what is real.

I share this writing to speak of the precious
treasures found in the divine plainness we are.
Sanity lives in what is plain and simple—and
so can we.

～

~

Yesterday, I had a wonderful idea;
it is still with me today, so I will tell you.

I would like to paint. See, over there, in that far
corner of the garden, where there is standing an oak
tree near the little fountain, there is a leaf on that oak
that is missing its coloring. Now, I believe that oak
hasn't noticed. I'd like to fill it in.

I think I will.

~

*I have a secret paintbox. I have told
no one about it till now to us, but I know that
you understand. It is a magic paintbox given to me by
the Gentle Being of my truest self to take with me into
this Dream. She promised that it would keep magic
in my heart and bring color to my world.*

*I can tell you that I am creating a
wonderful garden with my paintbox, putting
into form the certainty of the Eternal Presence. I
have never spoken of this treasured thing before, but I
love and trust you. The Spirit of the Earth has
given me a patch of canvas for my very own
and encourages me to trace upon it
the dearest things*

I know and care about. I do this now
to bring into being the inner reality that I
would like to share with you.

Would you be happy to come and
share my gift? I extend to you this invitation to
partake of my little world and to have you rest your
weariest thoughts within the company of sweet,
silent flowers. Their soothing presence will warm
away your sorrows and fill your inner mind with
remembered Grace. There will come a lifting of your
heart, a glow to your face . . . oh I see . . .

it has already begun.

≈

PROMISE

The Many of One

~

DANCERS ON THE THINNEST thread glide between two flowers in my garden. They dance standing nearly still and hold their breath just long enough to ensure the step they take prevents the thread from swaying. I watch them in wonder. I'm glad they have come into this garden and not another.

I stand and watch as time, or my perception of such a thing, disappears. There I am, standing perfectly still, entranced by beauty that sweetly unfolds before me. I am not alone in this garden; people walk about enjoying its delights and their own conversations, and I don't understand why they do not see the little dancing people on the silken thread.

It is true no sound can be heard. It is a mute dance and merry only for the eyes. At least, I think it is with my eyes that I see them. Is it with my tired

human eyes that I see such a wonderful thing in a garden that was home to the ordinary just a moment ago? I don't like this doubt of mine, I want to find the portal that leads me to the assurance that this happy moment is possible.

I have the door open for you, says the voice with no sound. *It is very thin in here without you. You are the warmth of a full day well used and completely held up to the sun. I would love for you to come and play in the garden that belongs to you. Be of good cheer, dear, the wind beckons and the flowers lend their scent to show you the way. The pebbles on the path are glowing brightly and the chair with rounded corners is waiting for you to come and rest and find the peace you thought was lost. Why not relax? Yes, take a deep breath. Yes, dear, come within and let it all go. Let your heart sigh the tears of the past and see that you are left with yourself as something so fresh, so new, that the day hasn't even begun.*

Believe for yourself what you cannot prove to others. And why listen to others? They are beloveds who believe in the farce and the farcical, and they are asking different questions and are finding answers that would never satisfy you. Oh, charming friend, sit and let your breath breathe out the past. You are not being good or obedient to hold onto the clutter of a day gone past, that you, in fact, remember incorrectly. You need not heal anything. There is no incompleteness marring your life or your mind or your past. There is nothing to fear, nothing to control or to ward off or to keep at bay. Oh, you think there is. Thinking is the activity that has taken over your senses and your better judgment. Silence will show you the gentle world you seek.

Come, I hold the door open for you.

TENDER THOUGHT

∾

TENDER THOUGHT, where are you coming from? You exist in the quiet corners only.

The loud outer world is fully center stage and takes up room and makes a fuss. But you, tender thought, you are soft and reassuring like the breeze on a warm day. You are tranquil like the love that fills my heart in the midst of a meadow filled with tall gently swaying grasses.

You are the One I keep looking for and you are the One I need never seek, for you are nearer than the dearest part of me. You are the morning of every day that appears out of the mist of Foreverness into Time and Space. You are hidden but not lost. You are mine and you are me. I am what you are for

expressing, though I have come to express mostly what I have been told by outer concepts.

You are so quiet, so nearly not there, that I find it hard to find you, not finding myself too clearly in this world of "other people." But knowing You are here, is the only thing that matters. Isn't it?

∾

I See Above

THE COUNTRY ROAD

~

THE WIND MUST KNOW my name; for as it whistles through the trees, I hear it call to me.

I am walking along a quiet country road in the darkness of one night. High above, the stars are shining from an indigo depth that surrounds them and me.

I am alone but not lonely. All about me the wind is playing, blowing great gusts of wings that fly through my hair and beneath the corners of the cloak wrapped carefully about me as I move within its protective warmth.

I don't know where I am going for I have simply agreed to follow the road and trust that it will lead me. I am unafraid. I've been walking since the light of day and have met no other human. The road has taken me through countless splendors. I have seen creatures of great size and gentle grace. There have been natural

gardens, green with song, and empty deserts, still and stark.

The cloak enfolding me is made of the softest wool. Its colors stripe around me in shades of clay and sunshine.

Although it is the deepest part of winter, I feel no discomfort. Neither am I tired. Though I have rested but once at the fall of night, I have kept a steady pace since. Where I am going is the question at hand, but it is not uppermost on my mind.

I enjoy the movement of walking. My feet feel good in the beautiful moccasins my brother made for me a long time ago. I have worn them well and through many adventures. The leather has become pliable, molding perfectly to my feet. No part of them shows wear or weakness. My feet and these moccasins have become part of one another.

Because I love my brother and he me, his offering
has been a blending of his own spirit with mine. He
is with me tonight in the power of his gift and the
carving of his soul on my walking shoes. Together,
we make this journey.

The road is taking me somewhere, I have no doubt
of this. What looks like meaningless wandering is
perceived by my mind's most peaceful moments
as being surely led. I sense a destination with none
in sight. I understand I am not moving through a
mindless maze leading to unanswerable questions,
though no guideposts ever appear.

Under my feet and through the skin of the
moccasins I can feel the little pebbles that fill the
path. In the moonlight they are bright as candles,
glowing and lighting my way.

The pebbles feel soft to my feet. I bend down to
pick one up and my hand warms with pleasure

while unnamed tensions ease somewhere in me. Though I make no effort to hold the little stone in my hand, I find I cannot drop it from carelessness. This pebble is in my hand because it has chosen me and is inserting its own will in our relatedness.

Knowing this makes me grateful that I do not possess the power to harm any of life's creatures. Knowing this removes the weight of personal responsibility for making all things work. I become less encumbered with myself and less afraid of blunder.

I put the pebble in my pocket and give a prayer of thanks. The pebble and I are on a journey through time and space, but Eternity is writing our story.

～

The Country Road

~

I SHUFFLED ABOUT the Earth until one day
I said: What do I want?

*I am your wanting. Let me speak, dear heart. You
have been standing on the side of the garden that is
yours but enter it not. You wait by the gate that you
think cannot open to you and you weep from this
inability. Oh be brave, dearest one. Do not believe
what your emptiness tells you. Do not succumb to the
sleep that robs you of your joy. You have come to bring
the sprinkles of light that fill the gaps where all life
lives. You are here to reveal what the inner place feels
like. You possess the One who can tell of such quiet
things of which the world has need.*

*There, with folded hands, you quietly sit on a
rock that faces away from all things dear to you.
How can you look to the place where your love is not?*

Have you found it better to be away from the warmth
of the sun and the love that gives life to all that is real?
Of course not. You can give to yourself the wonder that
lives in your heart. Your heart clamors to be heard.
You try to hear with your outer knowing, but there life
does not live.

Let go of seeking understanding, for you do not know
how the truth looks anymore. But be of good cheer,
dear, the appearance is insignificant. It matters not
that you know. That is not the thing you need to know.
It is not the thing you need to remember. You carry
the weight of worldly wishes and dreams that slow
your step and confuse your horizon with a clutter so
complete that you are there by the side of your garden,
staring at a gate you think will not open for you.

Let go of all understanding and the need to make life
happen. The One within stands by your side right
this very minute and will take from you the burdens

you have carried. Give them up. Each and every one.
Lay down your burdens now. Do not try to know
what will unfold. Simply know that it can only be
wonderful when you are unconcerned for what it will
be. You are loved more than words can say.

~

∾

WHEN I THINK of nothing at all, the whole Universe opens Itself up to me. I am the receiver of such beauties that my heartbeat echoes the waves hitting the shore, while the wind sings just for me. I cannot distinguish between the ebbing and flowing waves and my heartbeat. Is it possible they are both the same thing?

When I stand perfectly still, my open mind is illuminated with peace and rightness. I am a joyful Being in quietude. Joy, the joy that I find within me, is deep with silence and countless reassurances that my outer mind craves. The reassurances I need to remain on steady ground never come from the world. The world has very little to give me, if anything at all. I look there too much, craning my neck, forcing my perceptions to reveal something of meaning and import. Invariably, I come up empty-handed.

At the very center of my being is the ability to be well and happy. There is nothing to make happen or wish for. It is the true nature of my self and I cannot become other than what I am.

How good is my nature, how sound and how unchanging. How pleasant it is to be me, to be here as I am and to know that all good is ever with me and as me. I am filled with Light, a light so pure that it creates all things out of itself. I let this Light shine by means of me and I let it go before me to form my path and fill the world that is mine.

All this, when I stand still.

~

~

GO TO AN ANGEL PLACE said the whisper in my mind, go to an Angel place and discover your world seen through your heart and be of good cheer, dear.

There are radiant places that live on moons that cannot be seen by my human eye. There is clarity of purpose that resides in my shadow and a form so good that *it* is the one that leaves footsteps in the sand behind me. I am the son of a squire who has no wealth in the world but *is* the world, and the source of all that becomes this moment that knows no other time. There is a round sun in my sky that shines forth in my heart where it originates.

Tell me a story, said the teddy bear sitting on the bed. Tell me a tale and make it sweet and hold fast to the storyline. Never wander far from it. Tell me the story about my home and yours and how we're there now but do not see it. Tell me a story about

this room I find myself in now. Tell me a story about getting lost and that I am not what I appear to be.

Tell me tales full of wandering and wondering and searching for the thing never misplaced, the host ever present, the home always at hand. Tell me about my life as a self and my heart as a lover of life and my soul as Infinity.

Tell me the story of myself and the wonder of the thing I am. Show me how to reach the stars that live in my inner being and how to open the wings that lay dormant in my knapsack. Show me the path that is strewn with pebbles glowing in the dark. Show me the desert that teems with life. Show me the mountain that permits me to climb and never fall. Show me the light I think has dimmed and show me that I am the lamp that holds it brightly aloft.

Show me the way to myself and the way to my heart that has never been held in sadness or wanting for a single good thing. Show me the mirror that reflects the love that inhabits me and has given rise to the expression of my being.

There is a gardener that lives in my garden, tending the soil that needs no tending, for the two of them are one. There are inhabitants of countless other worlds in my garden that come from the same place and sing songs together with words they never knew before. There are small creatures and big. There are soft thoughts and majestic ones. There are dances of delight for the creatures who, not knowing one another, find the common strain of melody that holds them all together. There are surprises that were known forever.

There is happiness that is expected. There are love offerings that never end or know depletion.

There are raindrops falling in my garden that form a kind of dew, building upon the early morning moisture which creates a world of magic that looks like all the stars in the heavens have fallen into my life for the delight of my senses.

Go to an Angel place, said the whisper in my mind, go to an Angel place and discover your world seen through your heart and be of good cheer, dear.

Hand in Hand

THERE IS A LITTLE BRIDGE

~

THERE IS A LITTLE BRIDGE that I can see in the distance from my front door. It curves with ease over a very small river, and the other side looks inviting and easy to reach from here. I am grateful to the little bridge for spanning the water so well, fulfilling my need to cross. I am helped in so many quiet ways in this Time and Space world. How, I am wondering, can I help a bridge?

Who asks this kind of question? Oh, I will not attempt to answer that. I will ask only for the day to be long with comfort. I will ask the clouds in my sky only to weep from fullness of being, not from sorrow and loss. And I will go quietly, simply, into this writing. I will open up a little place for myself to observe what exists in my silent self.

Yes, I will not think; I will give up all that and allow myself to be soft inside. I will be quiet as once

I was quiet. No thoughts colliding one another for attention. No need clamoring for attention.

I will write but not think and I will walk down quiet corridors. They are mine and they offer countless choices, countless doors opening into vastnesses that promise many things. But I do not want many things; I want life, in all its simple beauty. I want the serenity of stillness.

I want happiness—the state of being at peace. The place where the mind is rested, unconcerned with what it experienced before, unconcerned with what will be—the moment of fresh awareness, delightful in its surprising aliveness.

I will sit by the cool stream, take off my shoes and socks, and let the water gently still all parts of me. My poor mind has been so overtaxed by me of late, and in this lifetime, a very great deal. I have filled it with great big balls of fluff that are too heavy, too dense to bring clarity.

Oh yes, my poor mind. How busy it has been doing what it is not designed to do. Be still, I say to it now, don't fret. Fretting will not make the world work better.

It is so quiet here in the shade of another time and place that is not this city with its sirens, its darkened sky full of rain. It is nice by this brook and the tree that holds my back against its soft moss. This tree is my friend from long ago; we have covered what is called years together, but mostly these distances are instances of learning. We have learned together and we have taught one another, and the deep bond that connects us is eternal and strong, though built of the softness of love's affection. We are soothers of affection, we are.

It is nice, this moment by the stream, isn't it? It is good to remember friends who live inside another part of us. How nice it is to wake up for a while.

\sim

ENCHANTMENT

~

The Dreamer

WHERE FIREFLIES DANCE

~

SITTING ON TOP OF THE MOON where fireflies dance, I know happiness as I sway to the soundless music of their wings.

Theirs is the only light tonight, and the air is cool, for the summer whispers have become rare. I arrived here long, long ago, when the desert winds reached up to this moon and the coldness within it evaporated as warm sands formed the peaks that you now see.

That was when I first became curious about the little blue planet that spins some distance away. I want to visit there but am afraid, having heard so many fearful things about the presence of great unhappiness. I've dared to travel only as far as its moon. It has been a long voyage from my native land, which lies just beyond the horizon where the stars become something else. I have remained on this very spot since I got here.

I am building my courage to fulfill my journey to that intriguing planet. Those I have left behind think me foolish, knowing it as they do, saying that it is a not quite refined kind of place. Perhaps it is something unrefined within me that draws me to it, but it appears to be such a graceful presence among the stars that I think, surely, it cannot be as bad as they claim. Not so dreadful and dreary, for aren't we all so safely held in a most joyful Universe, cause to all that is, and creator even of, sometimes discontented little blue planets that turn softly in a twinkling sky?

~

~

COME IN AND SEAT YOURSELF, my dear. I have been waiting for you. I delight in seeing your sweet face once again. Each new day dawns noisily for you as you become more unaware of the Quiet Place that lives . . . well, you know not where anymore.

You have entered a small room that seems to have no windows, for it has no walls. You no longer know how to live without the walls of mental definitions. Having lost sight of whom you are, you are in a panic that you refer to as *not mild*. It distresses you to be standing in an outer world you do not comprehend, nor do you encounter anyone there who knows the way out of your quandary.

Wherever you are is confusion. Here in this tiny room without walls, you stand awkwardly, as if you

are a visiting stranger. Your current perceptions fill with clutter this room that knows no clutter of its own.

The emoting of your many thoughts weaves constantly around you and appears to create outward solidity. The outer world is created by the definitions you make up about yourself. You hide from yourself, and as you do so, the outer picture closes in on you, "demanding attention." You think you must *look* at the outer picture to keep it in place and *separate* from you. But it is your outward focus that causes your confusion and that makes you feel that you belong to the outer world of illusion.

Your heart is often frozen in fear. Moving forward, it leaves you cold and uncertain. This brings you an even greater desire to keep yourself apart from the world that you think takes place on the other side of this room without walls.

Do not permit this confusion to continue, dear one.
There is clarity to be had. You possess unlimited
clarity. Be still and regain the truth that lives within
you. Put your focus upon that within and you will
find that the answers required outside have already
come to you.

Look to yourself and remain unconcerned with
what others are doing or thinking. All are contained
in wholeness, and the world does not need your
scrutiny to become a place of peace.

Be of good cheer, dear, for the tide turns as you go to
the quiet of yourself. Let the world drop from your
concern. Let the sighs of others' despair not enter
into play in your in reverie of things as they can be.
To rely on your own quietness is quite sufficient to
bring true order to all that affects you. Others can
only benefit from the freedom you give yourself.

You are Light. Do not wait to set it free.

~

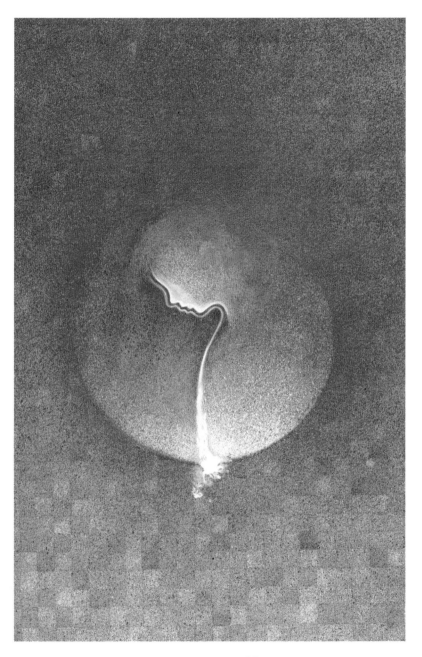

I Create Myself

THE PLACE I MISS

~

THERE IS A SWEET STILLNESS in the house I built with wishes. There is, too, nearby, a pool of Water so clear that I can see beneath the darkness my forgetting makes. It is the stillness that I drink from to replenish myself. It is to its moon that I go to have tea and stroke the cat that sits on the crest of light that looks solid, but isn't.

In my room is a mirror that makes the "outer" world reappear each day, but there is no wall to my *thoughts,* for I am roaming a universe that is open and alive. I am the traveler from a boundless realm, and I freely spend words of Love as if I carried all of Time and Space in a little bottle that knows no limit to what it can carry.

I am repeatedly asked my *name* in that outer world, the one that slowly spins to make a night and a day; the one I go to when I sleep. I am asked for the *time* and the *season,* too. But I never know what to

answer, and when I answer some 'expected' thing, I know I have said a thing untrue and unimportant. And so I sigh at the lie and I sigh at the spun air that I weave out of conformity, giving the other the feeling he has, nevertheless, received a gift of great measure.

I've been doing this a while now, and it always seems a bit silly to me, I so want to be more than in a sleeping dream of separateness. I want to *stay* awake, for I miss my little house with the low ceilinged-rooms. I miss the morning dew that falls from the stars and the sun that says it will shine all day because it *wants to*.

I miss the tales they all tell the Beings that, while living in the spinning world, say nothing, for speaking there would create a puzzlement too great to bear for those who *might* hear but not believe. It is good to be gentle with that world. Too much happiness there carries the weight of great worry.

But too much worry happily keeps fears at bay, for there can be only so much noise going on at one time. It is easy to overload a mind believed to be finite. It is easy to lose sight of what is thought to be merely form.

It is such a cockeyed little world made from spun threads of illusion. And when I'm there, I miss my quiet house built with wishes.

~

~

THERE LIVES IN ME a little dam. It sprang a leak one day, revealing that it had been created, not to hold back devastating waters, but the sun and all its glorious perceptions.

Be less obedient to the world, murmurs my Soul. *Hear within you all that is needed and sufficient. Take no one else into your confidence, let your voice be single. Only you can hear the presence I am in you. Receive with an expectant heart the gift of My presence and express it to yourself. Your trust in Me, by means of your trust in yourself, will carry you to the desired lands and to the depths of understanding that you have been calling out for. See how the words being uttered here open your feelings of gladness. This internal dialogue between us is real and more significant than any other in your outer world. You are the means, and I am the Self.*

You do not need the agreement of the world. You do not need the permission of the world. You do not need the understanding of the world. In Me you will not be alone and lonely as you stand apart from activities that formulate a world merely appearing to be real and significant.

I am the flooring of your house, and I am strong and everlasting. You can stand on Me and let the magnificence that cannot be seen with eyes transport each moment beyond the obvious. You desire this. You deserve this. You are worthy of this. It is your calling to receive this from yourself. It matters not that you lost sight of it, for in having lost sight of it, you better understand its true value and you see how, by its nature, it can so quickly become invisible in this world.

You have done nothing to diminish Me in you. Only your self-doubt has accomplished painful things that trouble you. You are not to make the world a happy place. It doesn't need happiness. The world is not a place. The purpose of life is not an outer construct. Its only activity is expression—

not outcome. You know this; be at peace with your knowing and don't attempt to form a consensus with others. Say nothing. When using language you only move an empty wind. Do your work quietly and trust that what has yet to come into focus on the path before you will be made manifest out of gentle and expectant unconcern.

~

Are You Listening?

THE GARDEN GATE

~

ENTER THROUGH the garden gate that hides
beneath that hedge, dear One. There are other
means of entry but none work so well as the quiet
one, the one hidden away and traveled less, for it is
the moon's own step that precedes you through the
tiny opening.

There are flowers lining the walk that takes you
through. The quiet candles they hold will light your
way with hope and assurances from the place within
that brightens the night with song. If you were to
speak about it it would be felt to not be possible.

Just let me through, says the murmur that opens
your heart. Just let me happen, as I will, for there
is nothing to do in your life but allow. You can let
this thing you are come out and be free. You can let
this inner knowing speak, and in you will be said
what matters to you that brings you delight and
that shows you the way through the maze of outer

constructed thoughts accepted by you and so many others. You are not alone in the loss you feel. Yet there is in you the presence of the unique voice that can be heard and it will sing for you, for it is you.

You yearn for your own beingness and you yearn to be at peace with this thing you call yourself, and the way to this oneness, is to see no otherness in yourself. You are the thing you know from deep within. Allow this to be seen by your dear mind and relax and let your song sing itself without the constraints you place on yourself to BE a certain way.

There is nothing to be but the thing you are. And it is a sweet and simple thing, this thing you are. It holds your entire world in a glass of water while you watch as the sun shines through it to reveal what is so perfect, that only the Eternal Sun, in its highest glory, can compare.

The wind that moves its breath in the hills beyond brings the seeds for your garden and promises that

the day will be long with gentle sunshine and the night restful as you fly to other lands and release from within yourself other creatures that you express and bring into being.

There are frequent whispers heard round the windows in your house. They come from the small children sitting in a circle in the inner room with no light. They tell stories, and the only light that is needed is the light each sees from within and brings forth in the telling of the tale. They are small children but ageless. Their wisdom goes beyond time and space, and they open any space in which they find themselves. They are quiet beings yet full of laughter, and their joy colors the outer sky. They grace all things about them, bringing order to chaos and peace to pain.

They inhabit your garden and await your return. Enter through the garden gate that hides beneath that hedge, dear One. It is time.

~

A Little Secret

~

I HEARD A RINGING. My ears were talking to me again. They did this occasionally when they had something to tell me and I always listened carefully.

The ringing sounded especially sweet today, now fixed in a position just above my head. I felt drawn to look up. This was a *mental* stretch, not one I actually made with my eyes. I saw a little yellow Moon perched behind the picture frame upon the wall, the one with wallpaper gaily decorated in little white flowers on a pale blue background. I didn't know what a Moon was doing there, as I was more used to seeing it hanging in a night sky.

The Moon beamed as if it could scarcely contain its secret another minute. It was aware of my presence now and rolled back its jolly round head laughing with unrestrained delight.

IT IS NOT ABOUT A MOON OR
A PICTURE FRAME

"Well hello, dear one! Come see the fullness
of the night expand. I've just understood
something truly wonderful. The Universe of
your world and mine is so good for bringing
us this happy insight."

With this invitation in hand, I entered the
picture in my mind and found myself in
a little drawing room the size of a postage
stamp. I fit in quite well, with room to spare.
The brightest thing in the room was the smile
on the face of the Moon. I found myself
smiling too. I smiled and smiled until, in a
twirl of a moment, my smile matched the
intensity of the Moon's. We became joined in
a synchronicity of joyful beaming. I felt myself
become more than I was before as delight
streamed through all that I knew myself to be.

"HELLO!" shouted the Moon now right
into my ear. "HELLO, HELLO, HELLO!
Aren't you glad you came to see me, you silly

dear?" I nearly jumped with surprise, for the greeting was belted out without any attempt at decorum. Well, this was going to be an interesting encounter.

I walked over to the Moon on the wall and with my hands on my hips, I said hello back. Then I said, "No need to shout, Moony, dear, I can hear you just fine."

"That's a relief, dear. Your compatriots have a serious problem, you know. It's a pleasure to meet one of your kind who receives loud and clear. You know, they're always calling up to me, and because they don't expect a reply, they never hear my response. It is quite annoying to be ignored so completely all the time. Still, you have heard me, and I am so delighted."

"Are you, Moon?" I asked, fishing just a little for reassurance. It's a very human thing to do,

as one does not always hear the truth when
one is visiting Time and Space.

"Oh, let me tell you true and assure you of
my heartiest pleasure in your presence." And
here it called my name, my full name that
none other than my own true soul knew best
and altogether.

I had not been called this since long before
this Earthly dream began.

"You said you understood something, Moon?"

"I have, I have—now picture this, you stand
on tiptoe fully, expanding the length and
breadth of yourself, and what do you find?
A bigger you? More of yourself to move
around? No dear, you find the middle of
everything. Did you know that *you* are the
middle of everything? That you are a middle?
In the middle everything can be found

EVERYTHING! So there is no need to look high or low, wide or far. Look only within. Inside, hidden out of sight where true sight begins, the very place you never think to look. Oh, isn't it ingenious?

"What is EVERYTHING, Moon? How can it help me?

"Everything, dear one, is being with all that you shall ever require. It is having, before you need. It is being answered, before you ask. It is being there, before you begin. It is the circle of hope fulfilled; it is the promise of success. It is the crown on your soul."

As it was talking, the Moon was sending little beams of light all around the picture frame upon which it was sitting. The frame began to shine very brightly and to quiver with gentle little gulps as if it were taking short picture-frame breaths. Do picture frames breathe?

"Indeed, we do," I heard the thing itself reply in a low dry voice that was just above a whisper. The sound suited its personality to perfection.

"Are you glad to be a picture frame?" I asked, not quite knowing what the protocol for speaking to a picture frame might be. Was it polite to allude to its "profession?"

"Don't you know that I take delight in the job I have to perform? See how well I contain the picture and conform to the principles needed. Here, I am a corner, and here, I am a line, and all this in perfect measurements. I dip and sway and have hard edges and rounded corners. I am made of the finest materials, formed by a gifted craftsman. I am a *splendid* thing, indeed. I have very important tasks to perform in the scheme of things. I am a unique one of everything. Like you and Moon here."

IT IS NOT ABOUT A MOON OR A PICTURE FRAME

The Moon winked. I was among a chatty couple of talking marvels that took themselves not at all seriously in all their seriousness. I was beginning to sense and to trust that I was not going to say the wrong thing. I relaxed. I put my hands in my pockets. Feeling a tingly thing in one of them, I pulled out a moonbeam.

"Oh, that's where I put the silly thing," said Moon. "I'd been looking for that all week and I quite forgot I had sent it to you."

"You sent it to me?" I asked, incredulous, but secretly quite delighted—I was no longer locked into a certain limited kind of logic.

"Well, of course, dear, this is by invitation only. I haven't any time for anyone that would waste it." The tiny moonbeam had become somewhat dusty in my pocket. Giving itself a good shake, it scattered radiant bits of fluff

to the far corners of the minuscule room, all of which landed here, there, and everywhere, giving the room a warm and cozy pink glow. The stars on the wallpaper suddenly appeared to twinkle and the minute I *thought* they actually were, did they swirl full force into bright and shiny beacons of sparkling lights. Then the blue in the wallpaper deepened and struck a fanciful shade of darkness that looked remarkably like a warm summer's night.

Oh, I said in my mind. Oh. This was such a wonderful place, truly unlike the hallowed halls of dusty, cold, heavy human drama. This was so much fun.

"Would you like to sit with me?" asked the Moon, sensing my desire to settle somewhere. The next thing I knew, I found myself, if my disbelieving self could believe it, sitting snugly up against the Moon, cradled in the gentlest pair of arms. This was such a nice place to be.

Secure and with feet playfully dangling, I had
landed in Grandmother's lap, sheltered from
all possible storms and discontents.

I took a peek at Moon's face and found a
thoughtful sweet gaze looking deep into the
heart of my shyness. I was not used to this
unconditional kindness and began to feel ever
so slightly self-conscious and curious. The
noisy laughter had subsided, giving room to
the gentle sound of tender acceptance, which
my mind was finding hard to totally absorb.

I wanted suddenly to tell Moon all my
troubles. I wanted to let myself rest, not
wanting to decide one course of action over
another. Tears were close to the surface of
my eyes and at the very next blink they fell
down my cheeks. I didn't want Moon to think
that I might be unhappy, so I quickly buried
my face against her heart and breathed in its
welcoming warmth and sustaining energy.

IT IS NOT ABOUT A MOON OR A PICTURE FRAME

Her skin felt like no other I had ever felt before and not like anything I could describe in words and pictures. It felt like something beyond the feeling range of my senses and I was aware of its presence only in my deeper self. Still, I knew it to be soft and warm and in some intangible way like a solid wind; it gave way to my touch. Oddly, this caring Being seemed to breathe in rhythm with my own breath.

I looked around me and found that I had a plain sight of planet Earth. It was far away but clear and beautiful. I suddenly remembered my first memory of it long, long ago, before I entered the district of Time and Space. Memories I thought forgotten returned to me. I regained a fullness of myself.

I relaxed and let myself nestle up to Mother Moon; she had quite clearly taken on the

maternal dimensions of all the nurturing that
Love can bring. There was joyfulness in her as
there was the whisper of contentment. This
goodness felt very real and I felt very happy.

The Earth below looked so inviting. From
this serene vantage point, it appeared even
peaceful. No wonder I had so wanted to visit
it and visit again. It distinguished itself by
producing a quite habitable environment
where questions could be asked and answered.

I was grateful for the respite of this time
away. Perhaps now I could regain an
understanding of my purpose in visiting
there. I had been wearing the mask of a
confused human being for some time and was
beginning to show the little scars resulting
from living in a bramble patch. I longed to
hold on to the simplicity I now found in
myself.

IT IS NOT ABOUT A MOON OR
A PICTURE FRAME

Soon I fell asleep. Or so I thought, as I
felt myself slowly leave my seated body
tucked into Moon's arms and watched in
wonderment as I floated into the middle of
Moon's center.

Inside was a world of indescribable aliveness.
Everything was a part of everything else.
There were no strangers about and there was
no discord. Quivering rainbows connected
all that my eyes could see and that my
imagination could determine. Soft laughter
echoed throughout this community of
thought that pulsated with the innocence of
childhood.

Nowhere was there one thing old. Nowhere
was there one thing doubtful. I saw light
beings of every imaginable description,
all connected; all independent, aglow and
alive with a Beauty that was intrinsic and
featureless.

IT IS NOT ABOUT A MOON OR
A PICTURE FRAME

Everywhere I looked I saw the Heart of the
matter. Hearts murmured in the center of
everything, of everyone, yet I heard only one
heartbeat. In an instant I knew I had visited
the cell of the universe.

This cell constituted the primary structure
and was the Self-containment of the One.
It was as if the light of one flame were
shining through a lens of cut glass, giving off
dimensions and dimensions of multiplicity. I
was seeing the many faces of the One, and I
was one of them.

As I entered the room of the universal cell,
all gazes turned to me and smiled. I was
recognized and welcomed home. Hands
reached out in friendly greeting. Everywhere
my name was said, accompanied by waves
of pleasure and tender embrace. In no place
was I left out, overlooked, or forgotten. I was
home again, for I had never left.

IT IS NOT ABOUT A MOON OR
A PICTURE FRAME

My heart was singing and I relished my new composure and renewed dignity. My place in the infinite scheme was assured. Nowhere in eternity did anything die. There was no such thing, no provision for it. Life was perfect. Unending.

Moon embraced me, filled me. So did the Sun and all the Stars within the Infinite Allness. Love was my eternal name. I would always express only this everlasting reality. There was Goodness at the core of me and it was reflected in every living thing that gave voice to itself as individual being. All was well.

And to think . . . all this started with a silly story about a moon and a picture frame.

~

AWAKENING

I Do Remember

PRECIOUS PLANS

~

I WAS SITTING ON MY CLOUD one day, thinking. Thinking and thinking and thinking about all the things I love. Soon these delightful thoughts were dancing all about my head, and I found myself crowned in fireflies.

Holding hands and singing at the top of their voices, these tiny Beings created waves of merriment as they bobbed and weaved about me. I became a little giddy and moved ever more deeply into the comfort of my soft perch as the dancers proceeded with their high spirits.

The book I was reading was filled with pictures of the flowers of the Universe. It was the Divine Blueprint for the wonderfulness that could be expressed in petal form. I traced my fingers over the designs of each one and committed to memory all the possibilities therein. I was dreaming of the garden I would have one day.

There is a little patch of cloud that I had reserved to practice my intention on. Each day I patted its soil and fluffed its mulch, then filled the watering can. I hadn't decided yet what to call my garden. But I was sure that, in due time, *it* would let me know its name. There was no hurry after all.

I loved my watering can; it was a present from a passing star on its way to arid lands. The container was beautifully decorated with engravings of tiny hearts encircling my initials. How the star had to come to have such a wonderful thing, and one so right for me, was, I knew, one of those great mysteries of this life.

But never mind, I was getting ready for my gardening adventure and it, for me. Rain had promised to keep my watering can well filled. I'd been collecting seeds year round, holding out my apron as each new gust of wind walked by. Never was there a day that didn't find a seedling or two

land in the corners of my waiting pockets. I tucked them all away in the tiny drawer of my sewing basket. I now had seedlings from every corner of the world and three from the farthest star. I had also put away that frazzled rake and shovel I'd found on my encounter with a storm cloud. They had been flung far far from home.

In a remote corner of Earth, I had spied a patch of land that felt right for my garden and I knew it was keeping itself for me. It was not very big but had a view of the mountains, the sea, and the stars at night and filled my heart with the purest happiness. Many a cosmic traveler will easily find her way down my garden path and see the trellis at the entrance with scented roses that braid a crown of blossoms in the most welcoming way.

For a while now I had been collecting stones and pebbles and was slowly sculpting the sides of the birdbath according to the very precise specifications

of the sparrow who comes for lunch each Sunday.
"It must be deep enough to soak in," she said. And
deep enough it would be.

I had long dreamed of my garden, a place of quiet
repose amid a teeming world vying for attention (I
am not always sitting on a cloud). There would be
a gate around my garden but no lock on the door.
There would be cool walkways between flower rows
and around the corners, perhaps even a patch of
wild strawberries and sweet melons, to quench the
thirst and tickle the palate on a hot summer's day.

The sun would stream gently into my garden,
always slanting its rays just right for bringing shade
when needed. And the wind, too, would blow the
gentlest kisses. I've told all the ladybugs that they
are welcome and they said that they would bring
their friends and children. I'm expecting butterflies
and bees, and thick bushes of hazelnuts to form the
western wall. The caterpillars and snails are already
packing, they said, of course, theirs is a long trip.

PRECIOUS PLANS

Large flat stones were waiting nearby to be neatly laid out in flagstones leading to the well. It is a wishing well, naturally, not for empty hopes but for all dreams that come true. And the wooden bucket you see hanging by my side will be full of flowers. It was a gift from the tallest tree in the forest just south of here, who fashioned it out of one of his large fallen branches.

My project is building momentum, don't you think? It won't be long now. I'm sure I've thought of everything. With *your* arrival it will be truly complete.

∾

The Star Gatherer

~

I CLIMBED THE STAIRS one by one. Gone were
the days of gently gliding over them, of slipping
through the air and landing perfectly where I chose
to land. I was very little then and my legs were
short, and it never occurred to me I could not do it.
I never doubted.

How I wish I could be that way again. What magic
of mind, what lightness of thought, permits the
body to soar weightlessly over the ground, viewing
only what it will of the passing show below? Still,
it is fun to be here, even in a rather *stalled* state.
This being a body has its interesting pleasures—it is
remarkable to be, at the same time, dense and light,
tangible and ethereal.

So, in this paradoxical state of being, I climbed the
stairs. One by one I climbed them ever higher. At
the top, a light glowed in a welcoming rich golden

yellow. As the staircase narrowed, a luminous pair of hands quietly reached out to me and I was lifted into a greater sense of ease and movement. My feet barely touched the steps. Any effort was not my own. I was transported. It felt good.

A rustling was coming from within the light. A very soft rustling of fabric upon fabric, breath upon breath, a light-hearted sighing. The faint clicking of wooden beads, no words uttered. What strange congregation of beings was I about to encounter?

I was unafraid. Unconcern for the outcome gave me strength to be open to discovery. Alien beings from another planet, I chuckled to myself. I had been in the human condition a very long time and my turn of mind showed this. I heard a muted giggle at the instant of my thought and felt I had been found out. *Somebody* had a sense of humor.

As I reached the top step, the glowing light parted and there appeared a passage being made for me. I

moved into this, my heart pounding; the stage had been set, the players were waiting.

I found myself at the entrance of a great hall. It was filled with the felt presence of many, many people but I could see no one. No faces, no bodies distinguished themselves to my sight. All was *impression*, and this kind of seeing is what I had ceased to recognize as real since becoming a human. My mind had lost its subtle touch with vibrational Reality.

I was still struggling hard with my need to include my eyes and ears in this experience when I sensed a hand gently coming to rest on my shoulder. I turned and found myself looking into the radiant face of a sweetly smiling older gentleman. He was every inch the regal patriarch, kindly and wise, with deeply patient eyes. His face was "real" to me, constructed of the familiar features of a human countenance.

He seemed to understand my relief and said:
"What is real is that you are open to the Moment.
It weaves for you the images that you will best
comprehend and love. You are a very powerful
being. Come join us for the Feast of the New
Beginning."

The man wore a long robe of richly woven fabric.
As I followed him, I found that I was similarly
attired, though I cannot fathom how it had come
about. My new garment felt warm, well worn and
familiar. I knew with certainty that it was mine. It
had *always* belonged to me.

There was music playing in the great hall. Although
I saw no musicians, exquisite chords of perfect
harmony flowed all around and through me. I felt
like dancing. I *was* dancing. Suddenly I realized
that the music was coming from the movements
I myself was making. I glided across the floor, my
heart, my arms, my feet moving to a music that
each sway *I* made created. I didn't know where

beginning began. It was clear now that the chicken and the egg—were the *same thing.*

Oh, how confusing clarity was feeling, but I easily succumbed to it. I fully gave in. I danced and I danced and I danced. As I danced in growing happiness, I found myself swept up in the arms of a gracious invisible partner who waltzed me round and round the room, my feet barely skimming the floor, my skirt swirling about me like a child's colorful spinning top.

I wasn't dizzy, but when the thought of what I was doing began to make me feel breathless, the merest contemplation of, "I can't," made all the music stop. It stopped so abruptly that I fell to the floor in a heap of disarrayed and rumpled skirt.

I was unhurt. Even my pride remained intact. This was funny and this was fun. The room burst into joyful applause at my inelegant display. I began to laugh. I laughed and laughed till the tears rolled

down my cheeks and onto my robe, where they formed a delicate pattern of diamonds all in a row around my waist. Nothing could go wrong here, it seemed. Disasters turned to delights and for all my clumsiness, I was the belle of the ball.

The regal gentleman came to help me back to my feet. He, too, was laughing, and his tears had formed minuscule crystals on his brows and around the edges of his beard.

I was upright again, still laughing, the sound echoing throughout the vast hall, where it seemed as if everything and everyone in it took delight in my joy.

How good it felt, this joy, this delight in living, shared with so many more of me. I saw I was a multitude; I was a *World*—existing for the simple expression of Happiness.

~

The Web of Wonder

IMAGINE A POOL OF WATER

~

LITTLE SPECKS OF PROMISE streak across my sky and leave a trail of stardust that falls into my garden. Brightnesses form within the crevices of petals and leaves, and the whole world glows from within.

Looking into my garden, I find a new earth that is as innocent as the freshly fallen snow and as ancient as the desert sands at dusk. I sit on my stool by water's edge and behold the reflection of all who have walked by my life since the beginning of Time. They all possess the same hidden treasure tucked into a pocket no one remembers.

But imagine that a pool of water could be so wise, so deep-seeing, and so much clearer than human eyes. Imagine bringing forth from depths unimaginable to the educated mind promises and gifts carried within, unknown to so many, for so long. Imagine.

I stagger with gratitude that I find myself near this profound, if plain, pool of water. And to think it lives in my very own garden, the place I walk through as the sweet soil makes my flowers grow. I am not alone on this wondrous planet giving forth beautiful expression of inner truths. All around me is a world abuzz with gentle activity; swarms of tiny movements form designs that bring a world into view. I can think of no other life than this: *to exist to be magician and creator of happiness in a world of form and function.*

It is a grand scheme that erupts each morning as I open my eyes from sleep. Somehow, seemingly "out there," a symphony of bits and pieces assembles, straightens up, as they shake themselves awake and begin to sing to me. And then, and then, with a kindness and generosity I can barely allow myself to receive, they tell me, in whispers my ears cannot hear, that the song I hear is *my own.*

~

I HAVE HANDS

≈

I HAVE HANDS TO HOLD out to the world as I
let the Light uncover the forms of my thoughts. I
have hands to till the soil of my soul and reveal the
ever new and never known before. My hands hold
the stars in their constellations and divide the true
from the false. They permit me to sing the song
that only the Child and the Moon can hear.

I am the daughter-son of the Quietness. I am
the only sound I hear. My breath is the echo of
the wind in my midst, and it carries all of me
everywhere. My heart is the heart of everyone, and
there are many faces to me. I am mine and I am
yours, and the truth that we are is known as I.

We may speak of these things, little one. Oh, little
one, how beautiful we are.

≈

THE SPIRAL STAIRCASE

MY HEART WAVES TO ME and bids me enter.

I move into a narrow staircase winding downward. It winds and winds in tight, perfect circles spiraling into the depths that lie before me, mysterious but inviting. This cave is my own, yet I feel shy and a little hesitant, like a visitor to an unfamiliar home.

The steps are made of wood, and I can see intricate patterns and writing on the delicately embossed banister. I don't understand the language, but the patterns are pleasing to my eye and in some remote part of me well known to me. Here and there appear inlays of gold and silver and metals for which I have no name. As I go farther and farther and deeper and deeper into the descending corridor I find the walls becoming richer in texture and heightened in tone. Vibrant, thick brocades are embroidered with all manner of scenes of the daily activity of my life. Every thought, every dream,

every wish, is intricately and delicately stitched by a clever hand that seems never to show fatigue or indifference to the task.

I gently run my hand over the currents of smoothness and roughness on the tapestried wall and feel the thrill of a conscious response to my touch. The wall knows me and welcomes my visit. I am happy beyond words. I step reverently upon the stairs and place my feet kindly on every waiting wooden panel. Slowly, slowly, there begins to be woven into the steps a rug of increasing density. Strand after strand appears, forming a stunning movement of braid that winds itself into the cavernous depths before me.

My footfall quietens and soon it is heard not at all as I tread over the new soft thickness beneath me. The yarns composing the pattern of the carpet are taking on an iridescence. The thought of a magic carpet comes to my mind and as it does I feel the steady ground beneath me whisk itself away and I

find myself standing on the long train of a bird of splendid plumage. I am now flying high above the spiraling staircase yet still I descend into greater depths within. I had not expected this turn of events and catching my breath from the air rushing past me I hold fast to the feathers nearest me.

The bird is flying at great speed, moving past objects that I am unable to discern, or recognize, or name. My heart is racing and I feel more than a little dizzy. Suddenly the thought occurs to me that I need not let my mind race on so, and it stops. Everything slows to a familiar pace and my thoughts return to a comfortable whisper. Now in command, I take a new look around me.

I am sitting most securely on the back of my bird. It is an elegant bird. It has a long golden crest at the top of its head that flies in the air above it like a shooting star. The fullest part of the crest glows like a flame and warm amber rays burst forth from it, lighting all in its path and sending

out an announcement of love to all who would be watching.

There is dignity and purpose to this bird in every movement of its flight. A regal manner that none could imitate. It possesses, as well, a gentle strength that gives it the appearance of exercising no effort in the action of its flight—I am being carried on the wings of nobility and order. I am a precious cargo. This knowledge stills my mind and brings humility and confidence to all my expectations.

Does my bird have a name? *I am the name of your honor*, is its immediate reply. *I am the you you seek to find. Be unafraid, beloved passenger, I take you only to the Beauty you feel you've lost.*

The bird sings its reply, its voice wrapping each vowel and punctuation of its pronouncements with little bells. I am filled with a long-forgotten pleasure in hearing it.

THE SPIRAL STAIRCASE

The radiant notes from its delicate throat open
similar places in mine and I enter into a perception
of myself that I have not had in the outer world of
human events. This trilling is the *meaning* of sound.
I speak now the language not only of ideas but also
of the immediacy of experience. The sound itself
is the presence of reality and in filling myself with
it I am no longer separated from true meaning. As
the sound continues to move through my being,
setting off chords of delight and happiness in each
and all of my cells, there begins a symphony of
accord and harmony that moves me to aliveness.
There is no place in me that does not have its part
to play, no instrument its note to sound. I am a
multiple sounding forth of the triumphant trumpet
call of well-being. I am a glorious thing to see and
to know myself to be. This is a journey to the long-
awaited truth of being. I am encountering *isness*.
Knowing that no unkindness will come to me, I
settle in for the ride.

I see far and wide about me. My usual fear of heights is no longer a concern. I am secure in the companion of my flight and relaxed in the knowledge that I don't have to know everything myself. I feel at ease with the present and free to allow what would be to unfold without need for control.

Glancing down, I notice that the garments with which I had begun the journey have somewhere along the way become the silks and satins now adorning me. I never before have worn such finery and I blush at the presumption.

There are flowers sewn into the voluminous expanse of skirt. In each flower a tiny star is sparkling. The sleeves are full and soft and nearly not there. Being made of something like star webbing and held together by nothing more than a breath, they are strong and real nevertheless. In the deepest folds of the webbing I take delight in seeing rainbow reflections that bounce off one another to create

an ever-deepening perception of reality that goes
far and wide and near and deep. The vest about
my bosom has the same red and gold threads as
the sash tied round my waist. I feel contained
and soothed in these garments. I feel strong.
Energy is coming to me from them with a sense of
supportedness renewed in each passing moment.

The buttons holding the vest closed are little
shining moons—each one different, each one in
perfect relatedness to the one bedside it. They talk,
they sing, they tell one another stories. All the
while this creates for me a silent world of wonder
in which to rest my mind. I hear them, not with
my ears but engraved in my living experience. The
realization of a profound and immediate goodness
swells in me. Life teems with life. The depths are
incalculable and endless. Best to let everybody sing
her own song, for there is nothing else for anyone
to do. Beauty is everywhere and has something to
sing about all along the way. Memories of a little

blue planet enter fleetingly into my consciousness. Has my journey there been merely a dream?

The bird alights on the branch of a beautiful tree that is standing in an open field near a large body of water. The tree is unlike any I have seen before. From its massive trunk, robust roots push their way deep into the earth with deliberate intent. While the tree looks ancient, there is a vigor about its movement as if it has *just* thrust its searching limbs into the ground. It crackles with such immediacy that in its presence my lingering accumulation of dust and mustiness is set free.

The branch we are resting on is surrounded by others just like it. Standing all together they look like a troop of dancers beckoning to the glowing sun. The sun they are reaching for is a blinding rage of fire. Light and more light than I have ever seen before emanates from the tiniest hole in the sky. Dimly, I understand that only this patch of light and nothing bigger is all my present mind can

see or my soul can take in. This tiny patch of light becomes a sun that the tree is worshipping. This is its reason for being.

I now realize why I have always loved the trees—because, I too, am a worshipper of the Great Light, Source of All—home even to those asleep to its presence within themselves.

I lift my willing arms to receive the warming kiss of wholeness from this Light. My body keeps me rooted to my illusory humanness but my heart is meant to merge heaven and earth. I know I am a messenger of sweetness and hope, and I now fully surrender to my remembrance of who I am.

I look at the branch where the bird had perched. It is empty. Puzzled, I search about and see no one near or far. Raising my hand to my brow, I find that my fingers have become minuscule feathers the color of light. Large wings jut from my shoulders. They fill the sky with sparkling drops of dew falling

upon all that can be seen and touched and heard and known—shiny crystals filling the vastness that reaches even into the Earth dream below, where the drops of dew turn into tears that twinkle in a night sky. The life within and beyond me has stirred into purpose and desire. My being is the seat of harmony and wholeness. Its loss has been merely a dream.

Soon I will return and resume my place in the dream. This time, in the dead of night, the tears will rain *hope* into every creature's garden while the world sleeps. The world will become a softer place but most won't know it . . . yet. I will keep vigil, for remembrance lives in me.

~

Begin

AND SO . . .

~

I MAY LOOK LIKE A SMALL moon to you. But I am—*a Galaxy!*

There are stars that twinkle in my joints and a rising sun glows in my folds. The wonder of the whole Universe is the landscape of my dreams and is the silent Promise within this life that I have come to create for this scrap of time.

And when all my human story has been said and done and duly noted and put away, I will return Home and enter this dream into a book that will delight the children who live in the sky and who open the day in the morning mist.

I will write that I remained alive from constant memories of things not seen by my eyes, retaining the taste of the sweetness that held no bitterness though there was sorrow around me. I will also tell how my faithful cup played at being full and empty,

while I juggled words that spun an ever-growing web of intrigue around me . . . by me, though I saw it not that way at all. Yes, and I will tell the truth about that land of Let's Pretend We Think It's Real.

Oh, it will be a splendid book, with an exciting story that will have us all laughing with delighted glee at the silliness and wild imagination that fueled the sometimes mystifying journey.

\sim

The Children of the Sky

30782383R00076

Made in the USA
Lexington, KY
16 March 2014